STEPHEN CHALMERS
UNMARKED

March 22–May 29, 2010
Reception: Thursday, April 1, 5pm

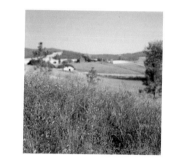

LIGHT WORK

Robert B. Menschel Media Center
316 Waverly Avenue
Syracuse, New York 13244

Gallery hours are 10am to 6pm
Sunday through Friday
except for school holidays

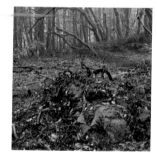

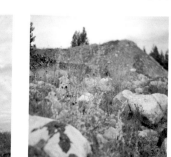

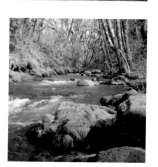

Undertaking a project that deals with death is a risky endeavor, despite photography's long-standing associations with the topic. An artist assumes many challenges with such work, not the least of which are the suspicious queries from viewers who wonder why someone would want to spend precious creativity addressing a topic that most people spend their whole lives trying to forget.

A good artist, one who really seeks, ends up discovering things that other people may not want to know, at least not at first. Sharing this knowledge in a way that makes others want and need to know it too becomes the driving force of the enterprise.

Photographer Stephen Chalmers has faced this challenge more than once in his multi-faceted career. In 2000, Chalmers, who is a trained social worker, former emergency medical technician, and professor, began photographing roadside memorials for his project *In Memoriam*. This project established several of the same themes and working methods that would later be further explored in *Unmarked*.

In Memoriam was started at a time when Chalmers was doing a lot of long distance driving, including moving across country to begin teaching as a professor in Washington. Occasionally he would see a memorial at the side of the road and would stop. He then went through the laborious process of making an image at the site using a large-format camera, no small feat under ideal conditions but almost miraculous with traffic whizzing by at sixty miles per hour. After developing the film, if the image interested him, Chalmers used the GPS coordinates he had taken at the site to find businesses and people who could help him do extensive research about the accident that preceded the memorial. Conceptually, by making a photographic record of a temporary memorial, Chalmers creates a lasting link between life-and-death events and the land. By inviting us to gaze directly on the residue of untimely and tragic deaths, Chalmers gives us courage to confront our fears about the end of life and its remembrance.

Tragedy was far from Chalmers' mind the day he had an experience that would serve as the genesis for *Unmarked*. The artist and his partner Diane went out for a hike on a gorgeous fall day on Tiger Mountain in Washington State. Later that same day, a friend told them that a serial killer had left the heads of three of his victims near the trails they had been hiking.

The contradiction between the beautiful landscape on Tiger Mountain and this horrific story became a lens through which Chalmers began to explore the terrain of the Pacific Northwest, a region endowed with more than its fair share of serial killer cases. More important was the contradiction apparent in memorializing some sites of death and not others. In the cases of the previous series, in which the decedents had perished in automobile accidents, the people left behind to mourn went to great lengths to erect visible memorials. Most of these memorials, although illegal, were allowed to stand out of deference in a social sign of acceptance.

In contrast, the sites where serial killer victims were placed remained largely unmarked if not unremembered by those closest to the tragedies. These places have a name—*dumpsites*—a term that comes from the science of forensics and has filtered into the vernacular with the help of TV crime shows. The connotations of this term hit a sensitive point: the people who died here were thrown away in an act of violence. That is a hard fact to confront, even as an outside observer. Facing this uneasy fact is what gives the images in *Unmarked* their agency. Acknowledging these sites and the people who died there through his images, Chalmers lifts a stigma that unceremoniously draws a line of remembrance between those who died by the intentional acts of another and those who did not. *Unmarked* returns remembrance of death from its deliverer to its rightful owner.

Although infamous acts may have driven Chalmers to the places he photographed, his focus throughout the project remains on the victim, both metaphorically and literally. Chalmers gathered a team of assistants to help him research potential sites; thousands of pages worth of trial records, police reports, and non-fiction books were combed through to determine the exact locations where a body was found.

The precise coordinates of the body remain important because this is where a seminal act of transcendence occurred. This is where an all-important question for those left behind was answered: their friend, son or daughter, husband or wife, colleague or neighbor was finally found here. This is where the dignity of the victim, his or her loved ones, and ultimately the land was

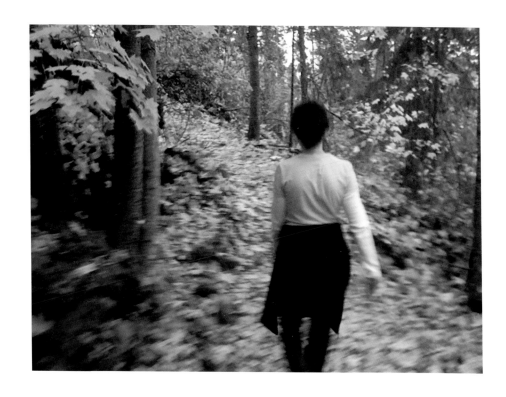

Diane on Tiger Mountain, 2007
Cell phone image provided by Stephen Chalmers

restored and allowed to begin the painful process of healing. Chalmers' use of selective focus literally trains our eyes on the victim, whose absence references the passage of time and the unintentional fading of memory.

In most cases, because Chalmers made the images long after the fact of the crime, there is no observable evidence in the photograph itself to evoke the memory of what happened here or the person who experienced it. A fascination with infamy is not indulged by learning the name of the killer, only the name of the victim. Likewise the sites, although they are beautiful, are somewhat generic. Nor do we learn any clue about the histories that brought Chalmers to the site in the first place. We are left only with quiet remembrance.

In *Unmarked*, Chalmers presents beautiful but ambiguous landscapes that seem to conflict with our certain knowledge that something terrible happened at these sites. While Chalmers treads on sensitive ground as he explores and documents dumpsites in the Pacific Northwest and beyond, he hopes to exchange sensational headlines and the inevitable scandal tied to such sites with something more meaningful. Instead, he offers an elegant memorial that shifts our gaze away from infamy and back to the humanity of the victims.

Mary Goodwin

4

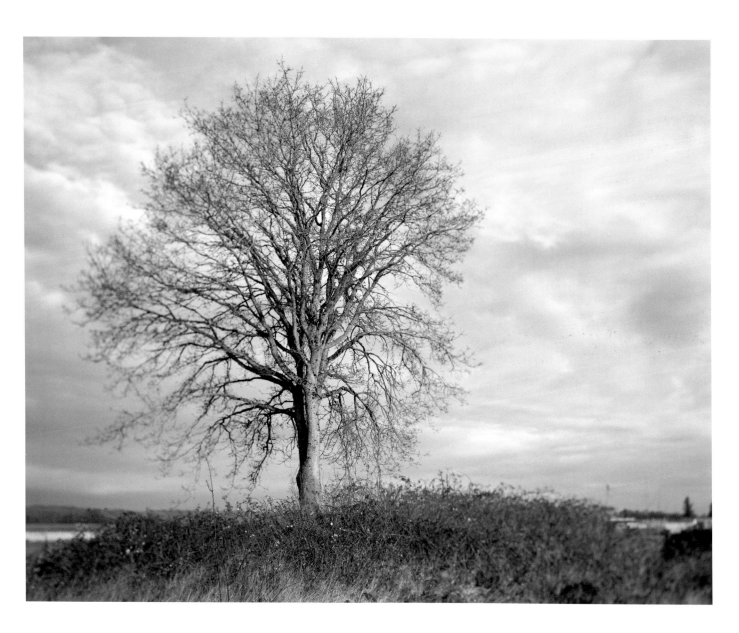

Brian Whitcher, 2008
All images are pigmented inkjet prints, 24 x 30"

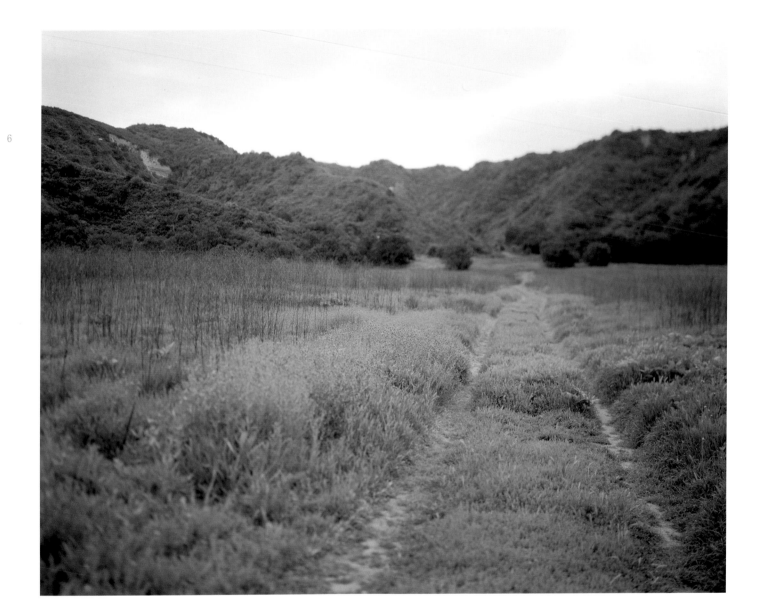

Dennis Frank Fox, 2009

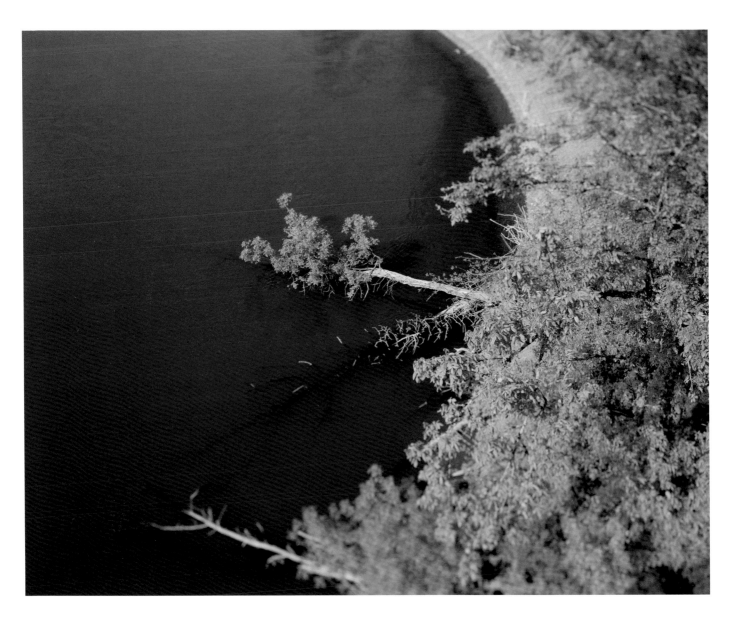

Jan Whitney, 2008

Connie Ellis, 2007

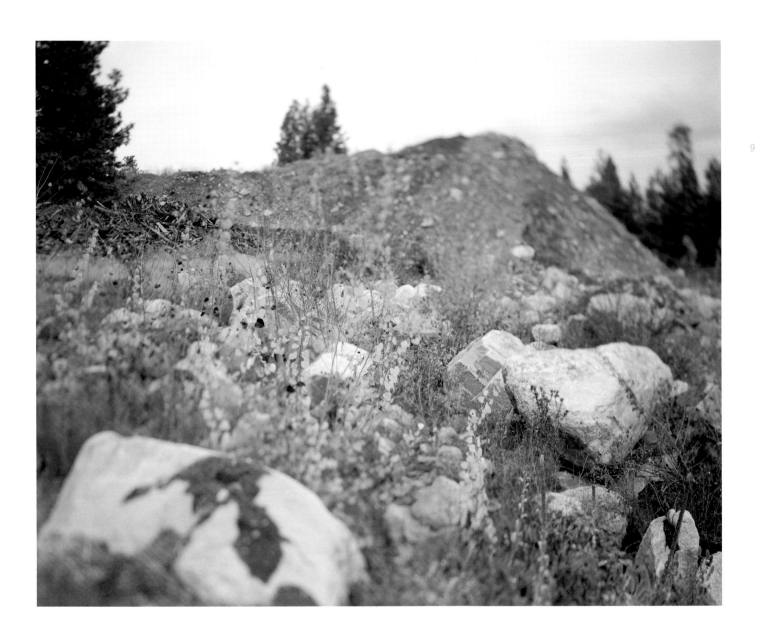

Laurel Wason and Shawn McClenahan, 2008

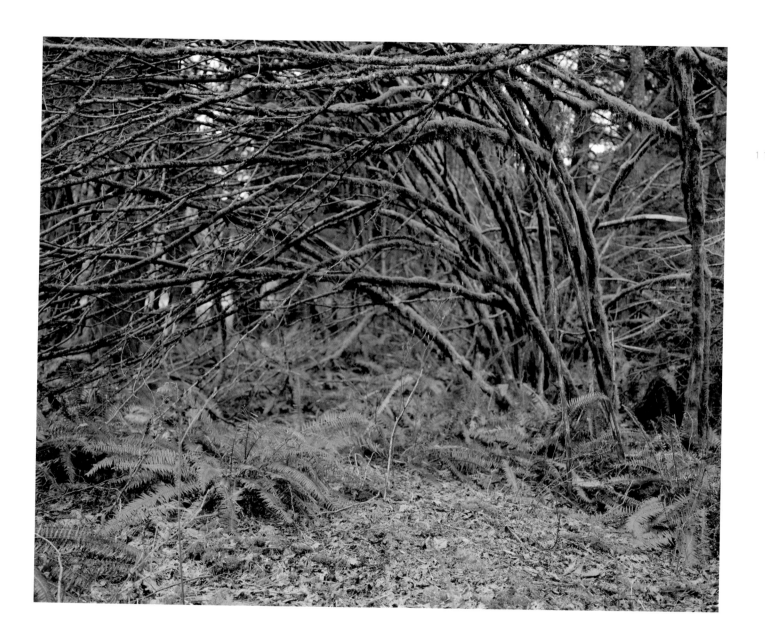

Debbie May Abernathy, 2009

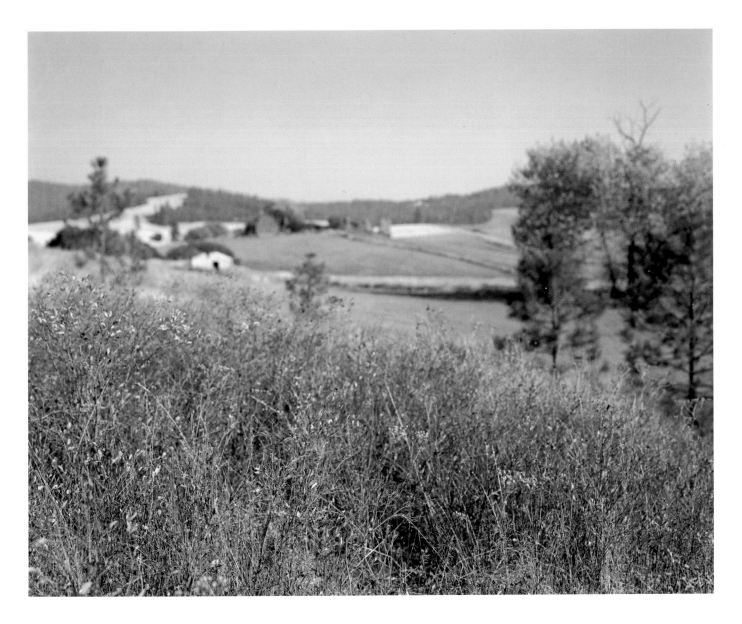

Jennifer Joseph, 2007

Robert Wyatt Loggins, 2009

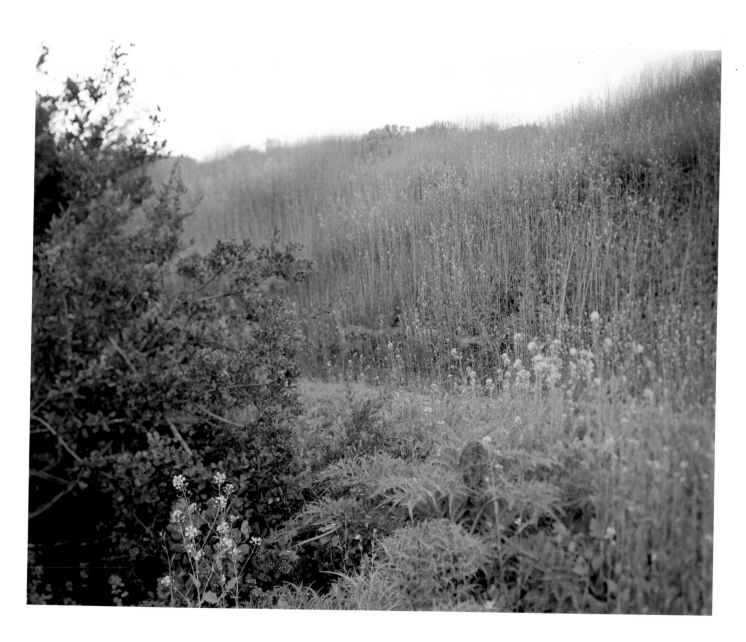

Gary Wayne Cordoba, 2009

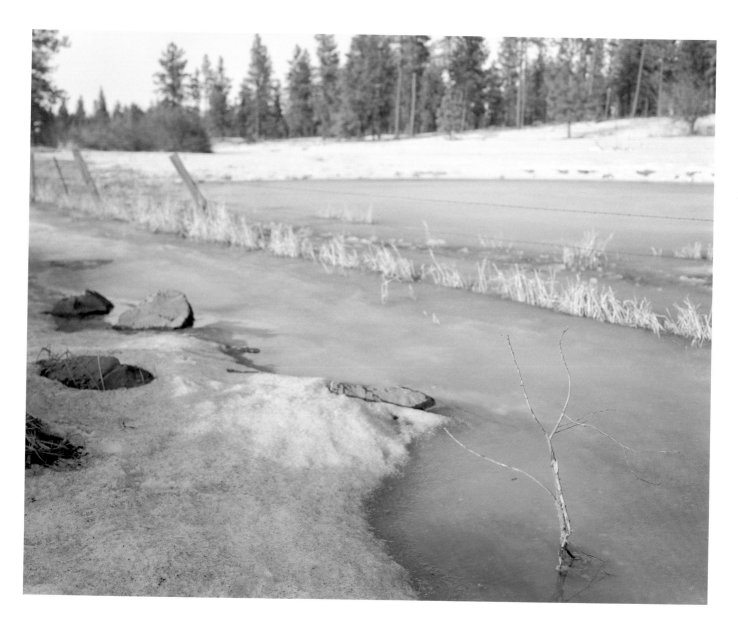

Sunny Oster, 2008

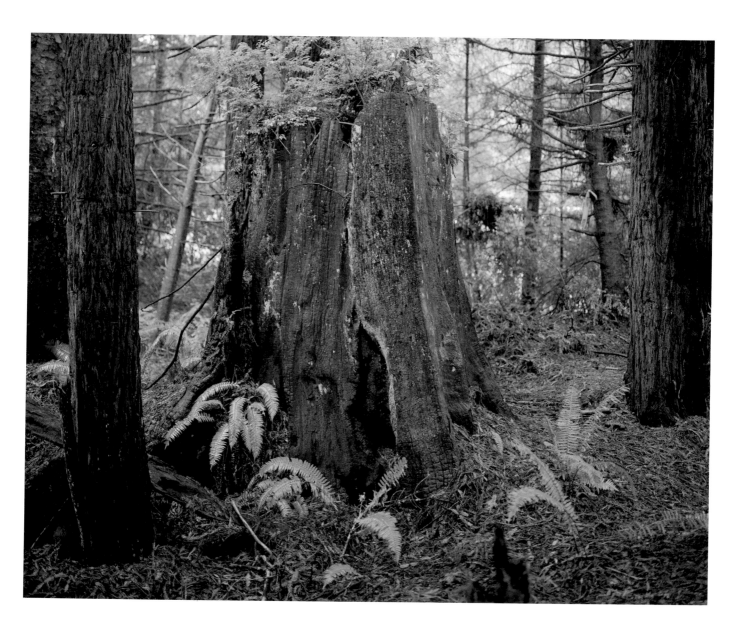

Jane Doe, 2009

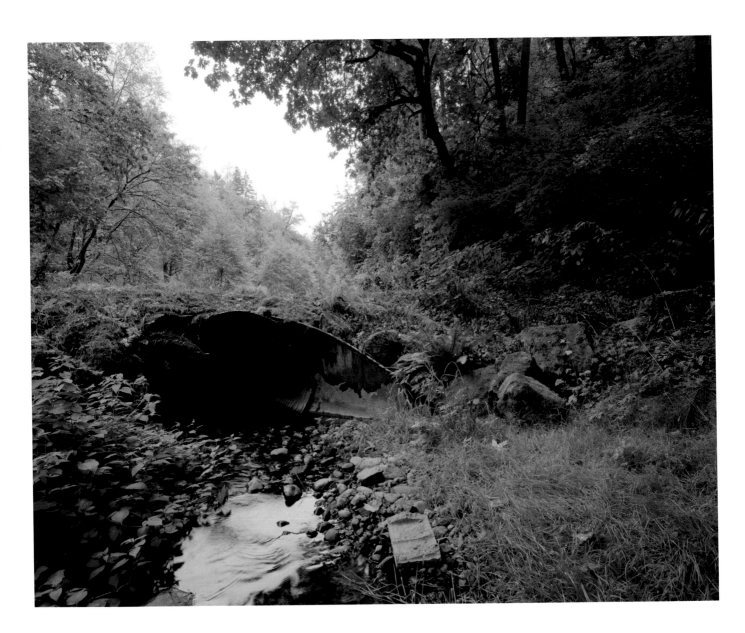

Colleen Renee Brockman, 2007

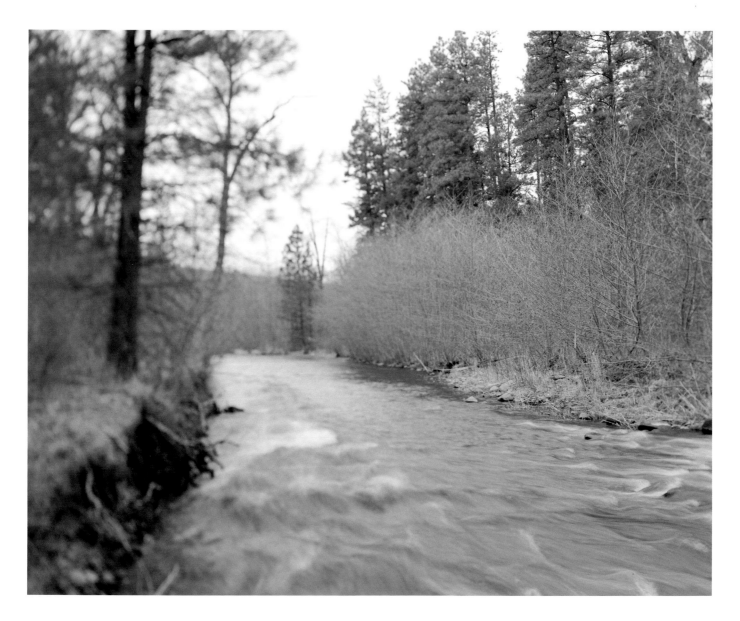

Patrick Oliver and Susan Savage, 2009

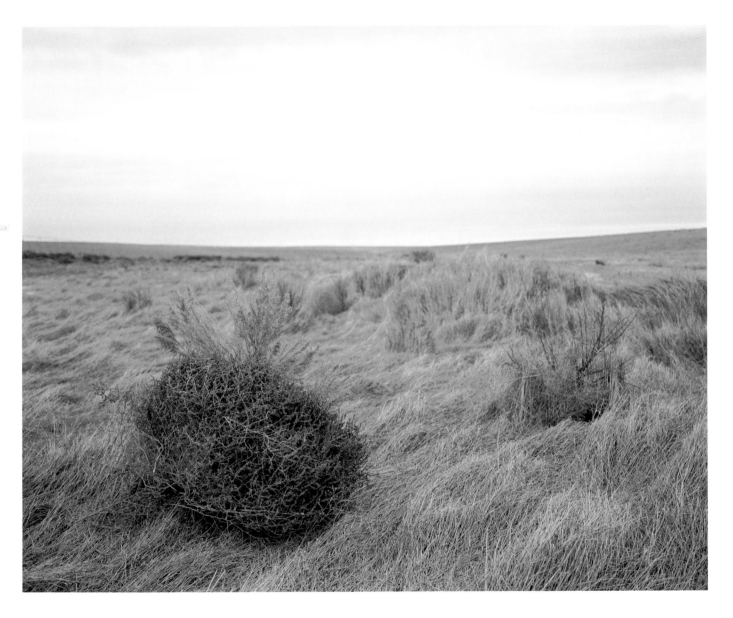

Diann Remington, 2009

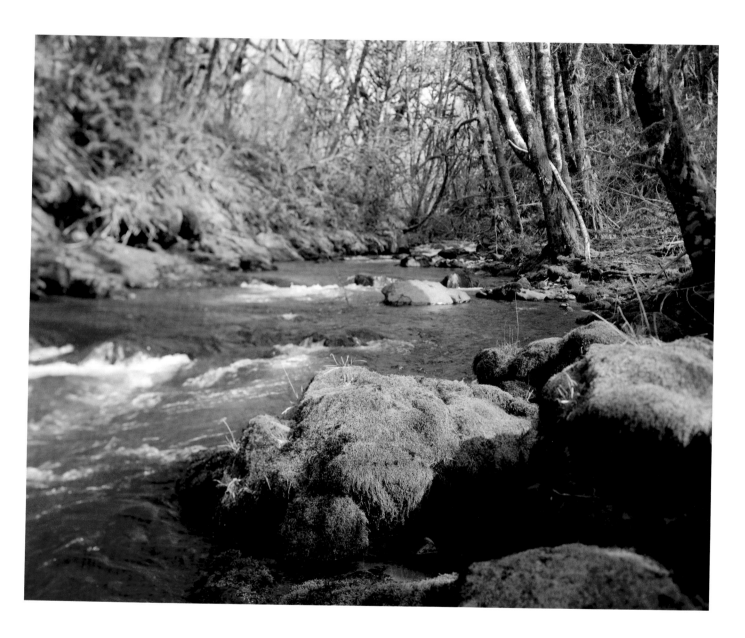

Rima Danette Traxler, 2009

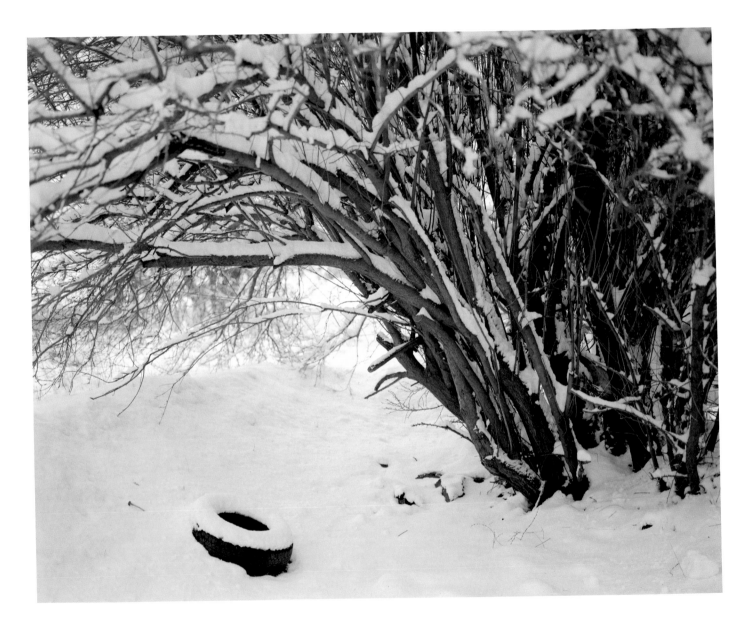

Michelyn Derning, 2007

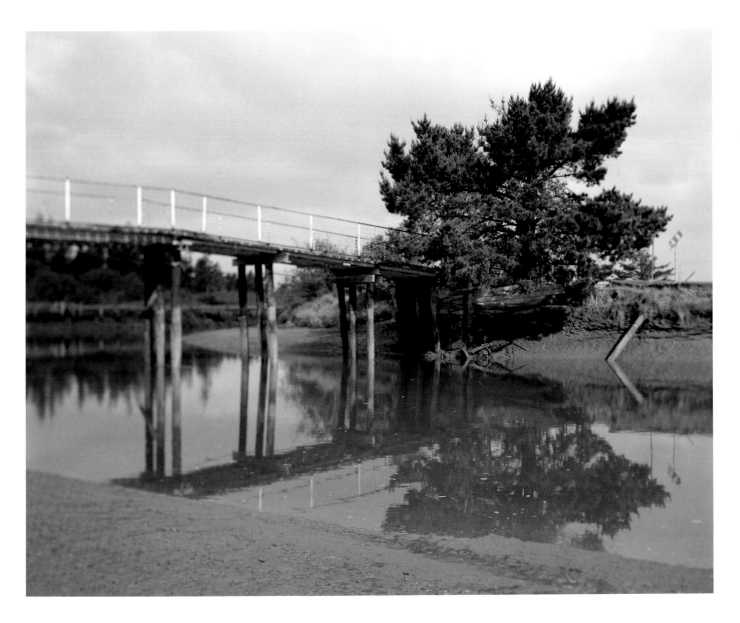

Jane Doe, 2008

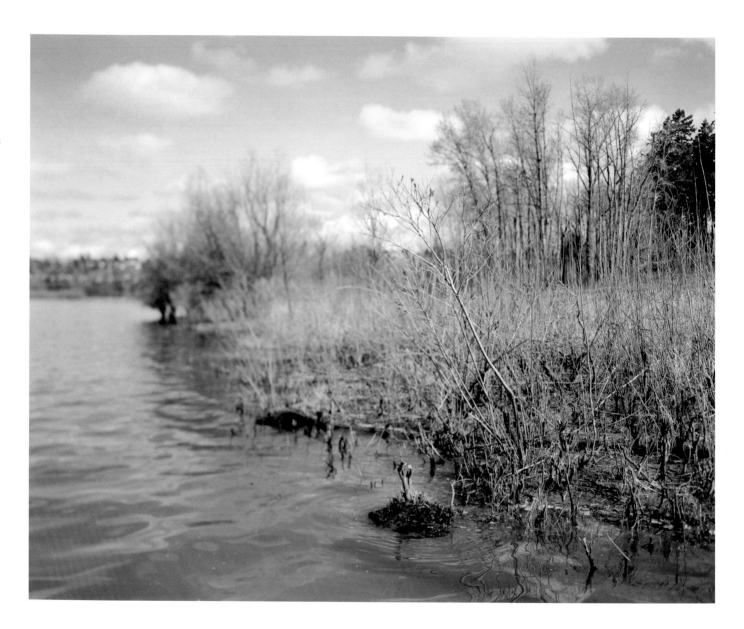

Lee Iseli, 2008

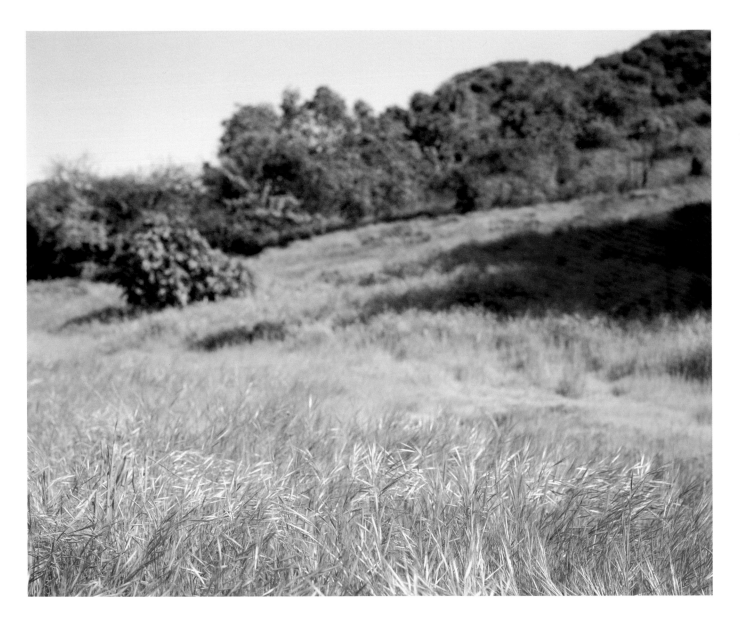

Yolanda Washington, 2009

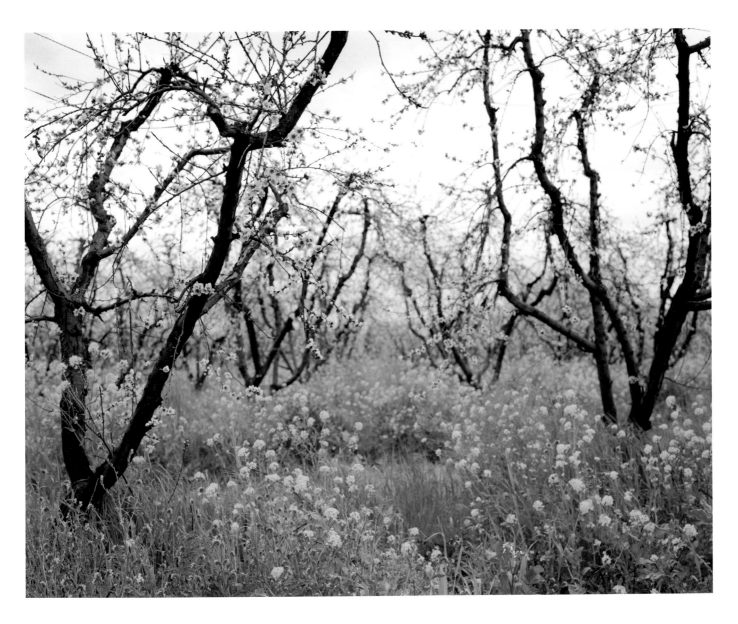

Paul Allen, Sigurd Beierman, Sam Bonafide (aka Joe Carriveau), Edward Martin Cupp, Charles Fleming, John Haluka, Albert Hayes, Clarence Hocking, James Howard, William Emery Kamp, John Jackson, Warren Kelley, Joseph Maczak, Raymond Muchache, Elbert T. Riley, Melford Sample, Mark Beverly Shields, Jonah Smallwood, Donald Smith, Lloyd Wallace Wenzel, Kenneth Whitacre, Four John Does, 2009

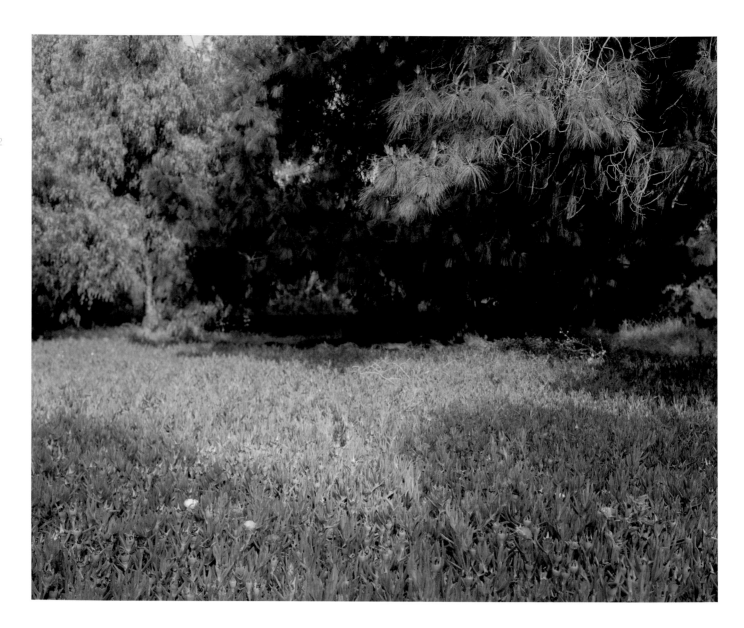

Eric Church, 2007

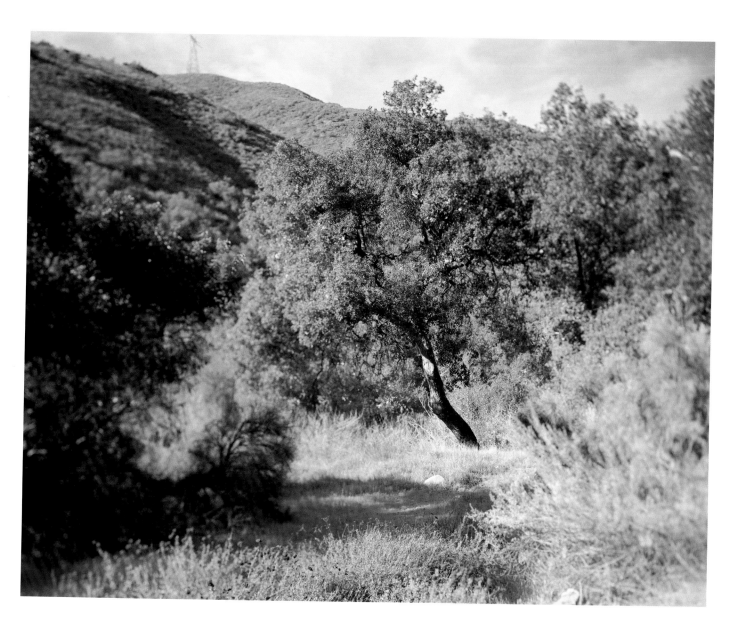

Mark Howard Hall, 2009

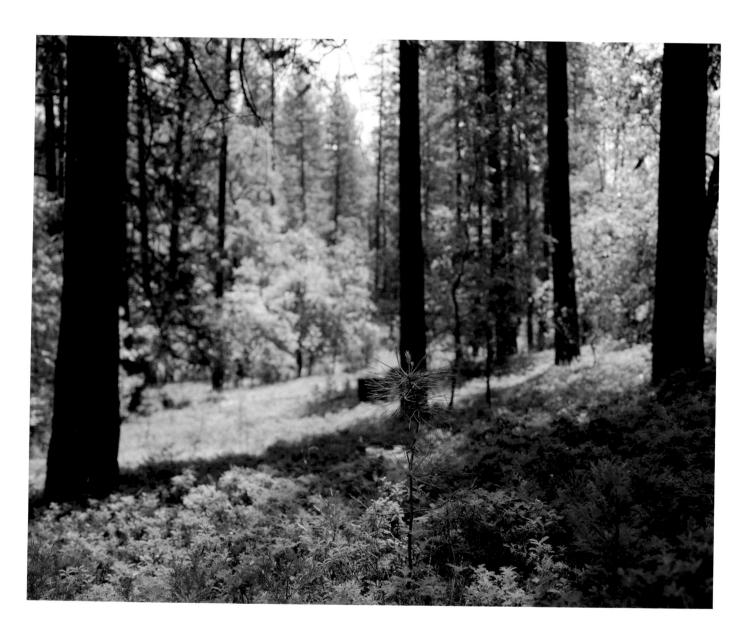

Kathleen Allen, Lonnie Bond Senior, Lonnie Bond Junior, Mike Carroll, Paul Cosner, Deborah Dubs, Harvey Dubs, Sean Dubs, Jeffrey Gerald, Randy Jacobson, Brenda O'Connor, Cliff Peranteau, Robin Scott Stapley, bone fragments suggesting at least 25 other Jane/John Does, 2008

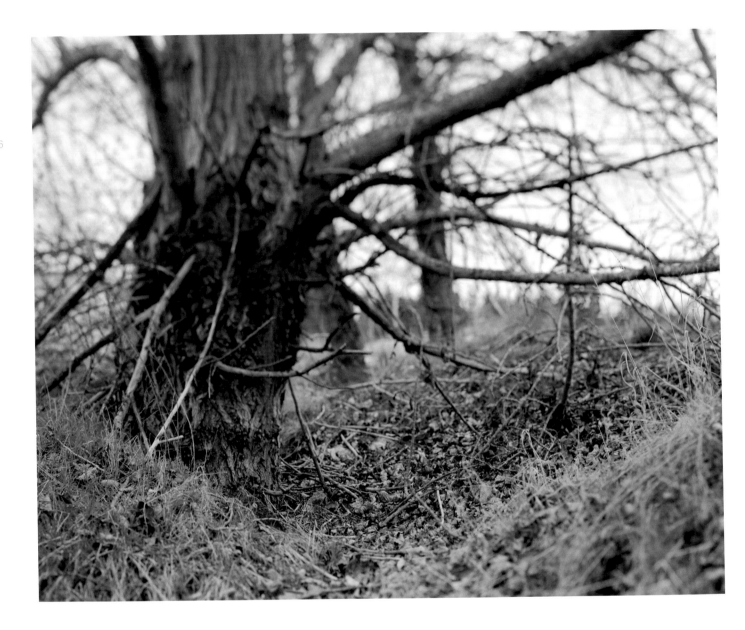

Melinda Mercer, 2008

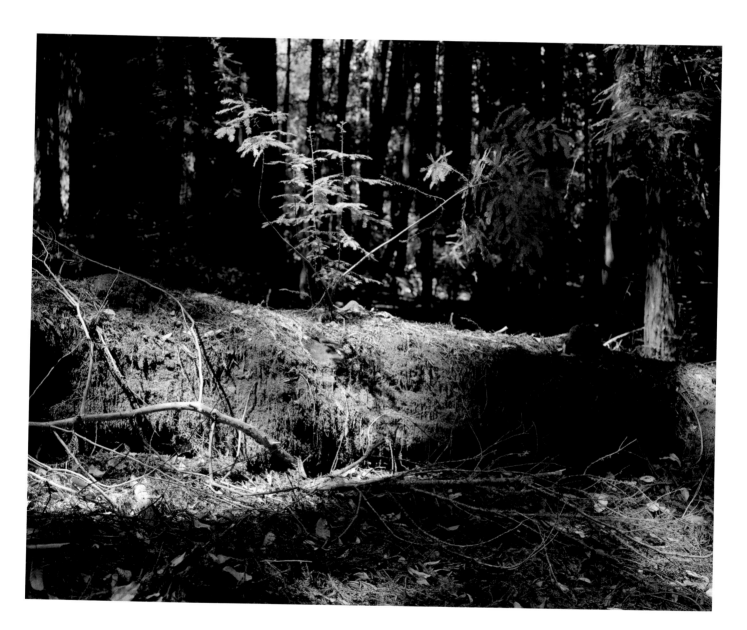

Heather Scraggs, 2008

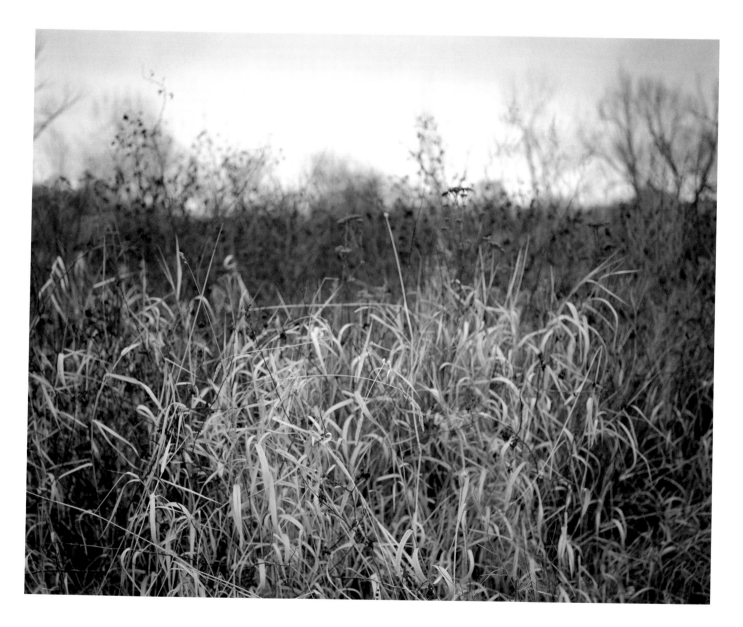

Marchelle Morgan, 2007

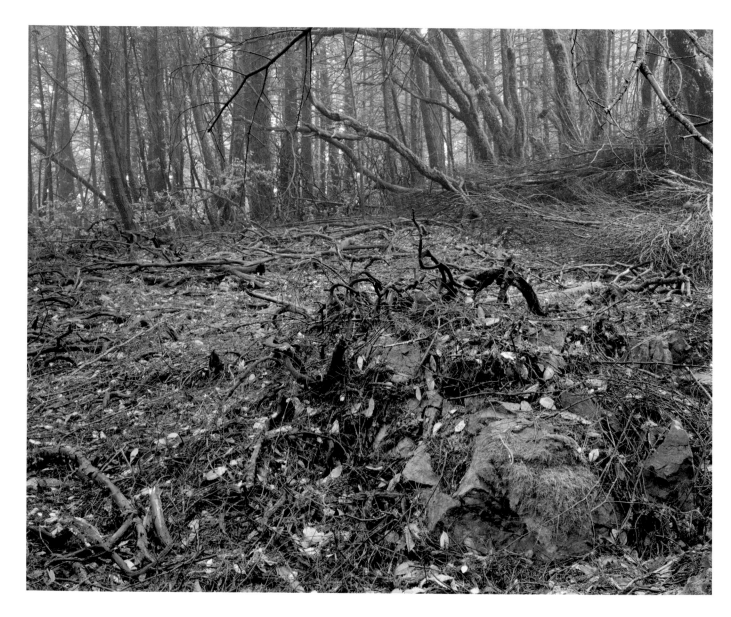

Anne Alderson, 2007

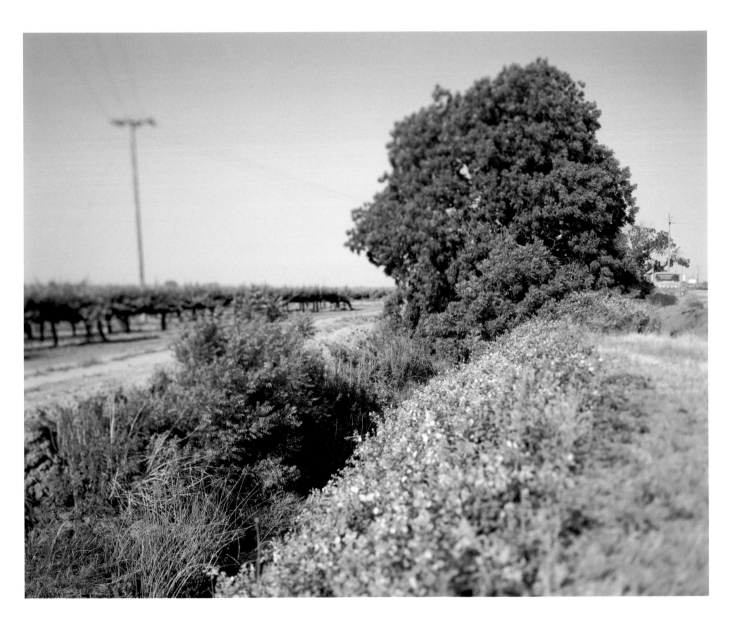

Lanette White, 2007

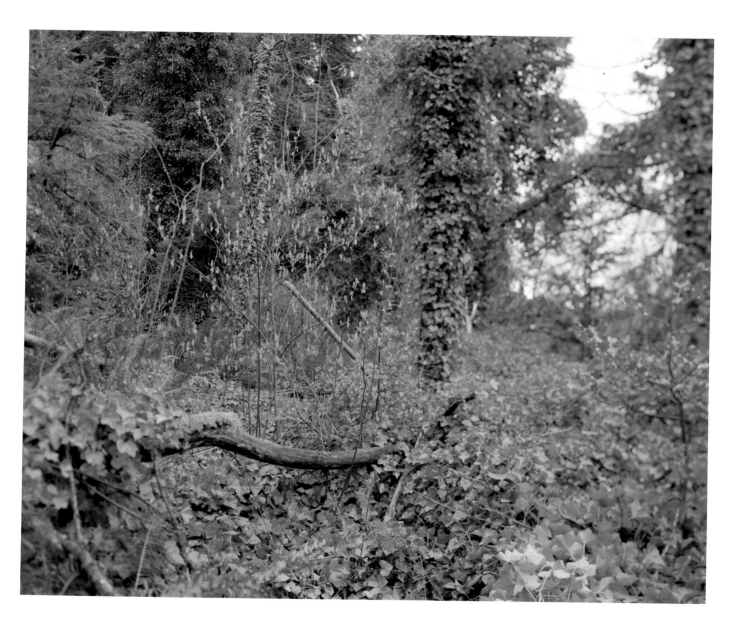

Martina Authorlee, 2009

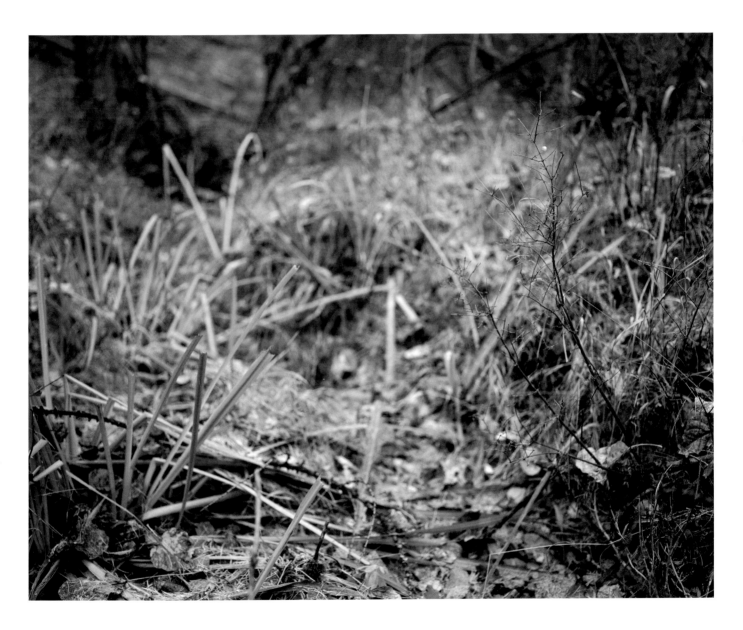

Sherry Palmer, 2007

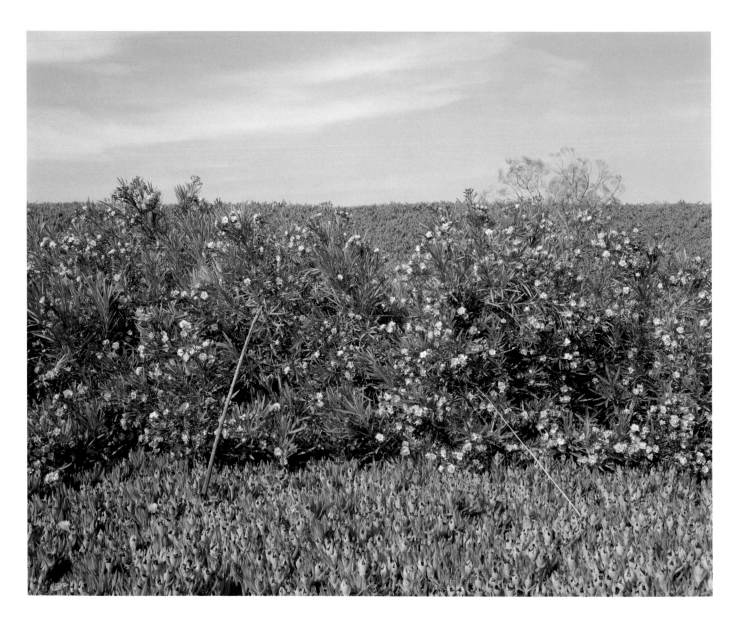

Ron Weibe, 2008

Stephen Chalmers has worked as a lead treatment counselor to severely emotionally disturbed children, worked as an emergency medical technician, and taught photography to gang affected youth. Each of these vocations has contributed substantially to his photographic projects that deal with issues of loss. Chalmers has taught many workshops in alternative photographic processes and digital imaging, and he has been a visiting artist at numerous colleges and universities. He has been a contributor to five books—most recently *Climbing the Ladder with Gabriel* (2009), featuring collaborative work with women who have overcome their addictions to methamphetamine. His work has been featured in group and solo exhibitions throughout the United States and in Australia, South Africa, and China. Chalmers' photographs are in many permanent collections, including the Museum of Contemporary Photography, Polaroid Foundation, the Getty Research Institute, and Light Work.

Chalmers earned his MFA in Cinema and Photography from Southern Illinois University and was professor of Photography and Digital Media in Washington for eight years. Additional biographical information, selections from his projects, and contact information can be found at his website at www.askew-view.com.

Front Cover—*25 male victims, CA*, 2009

When I was offered an Artist-in-Residence position at Light Work in the winter of 2007, I was working in a small rural community in the Palouse area of Eastern Washington with little access to artist peers. To say that Light Work was an oasis is a vast understatement.

I wish to thank the entire staff of Light Work; their talents and dedication speak to the ongoing success of the organization. In particular, I would like to acknowledge the following individuals: Jeffrey Hoone, whose vision and leadership during his 30-year tenure have made Light Work a strong and vibrant venue; Hannah Frieser for her invaluable guidance and generosity; John Mannion for his ongoing technical assistance and congeniality; Mary Goodwin for her insights into my work and her long hours curating the exhibition and assembling the catalogue; Mary Lee Hodgens for preparing the exhibition; Jessica Heckman for helping to publicize the exhibition and Contact Sheet*; and Vernon Burnett for his personal support and shared love of great food; and the many student workers who assist in all aspects of the operation of Light Work/Community Darkrooms—in particular Nicole Ciaramella and Andrea Chlad for their work in helping to make the map on the following page so clear and readable.*

In addition to Light Work's generosity, the Washington State Artist Trust helped support this project through its Grants for Artist Projects Program. Artist Trust is the lifeblood of artistic creation throughout the state of Washington.

There are many others whom I would like to thank for helping me realize this project: former colleague Brian Goeltzenleuchter for his tireless copyediting; former student Stephen Ellis for helping retouch images in a crunch; and the many others who have helped me acquire, sort, and annotate thousands of pages of police archives, true-crime novels, and prosecutor reports.

I wish to thank my father, Joseph, for instilling in me the love of knowledge and research—not to mention photography. I will always appreciate watching him tube-process Cibachrome/Ilfochrome in the former coal room of my childhood home in Louisville, KY.

Finally, I would like to thank my partner, Diane, who thankfully wasn't frightened away four years ago when she asked about the context and content of my photographs. Her continued support and encouragement have helped bring my vision to life, and I am thankful to her for being a source of treasured constancy.

Stephen Chalmers

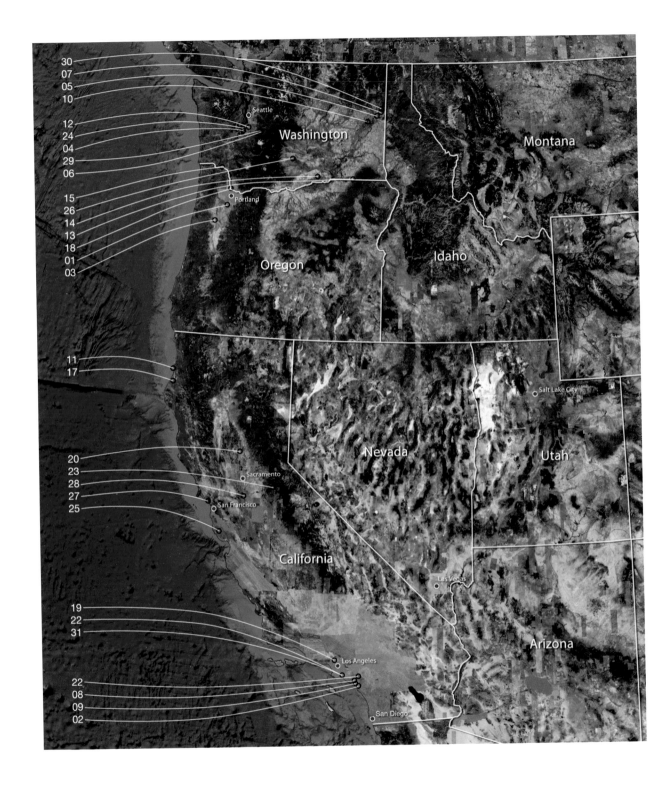